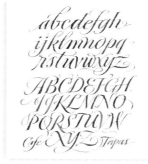

Lettering & Word Design

In a world full of digitized letters and standard typefaces,

the organic art of hand lettering offers a fresh, artistic, and spirited approach to beautiful writing. In the pages that follow, John Stevens introduces you to a variety of styles—from elegant and timeless to edgy and contemporary—that you can use as inspiration for a range of artistic undertakings, such as creating invitations, formal certificates, personal works of art, and much more.

CONTENTS

Tools & Materials

You have many choices when selecting writing tools for hand lettering. Pencils are often used for layout, but I usually use a pointed brush, broad-edged brush, pointed pen, broad pen, ruling pen, parallel pen, or markers for my letters. These tools can be used interchangeably, meaning that you can use the ruling pen instead of the pointed brush for a variation on any of the alphabets, depending on your skill level. Although you might expect to remove a tool from its packaging and have it work exactly as you'd like it to, some tools have to be modified or prepared to achieve specific lettering effects. An example of modification is to put a broad edge on a pointed pen by sanding it down with an Arkansas stone (See "Pointed Pens," page 7).

Below, I mention the brand names that I use because all pens, brushes, and inks are not created equal. There are no industry standards. The information I have included is based on 30 years of experience, but I also recognize that we each have our own preferences. Each tool has a cost-to-benefit ratio, and you will be more comfortable with some than you will be with others.

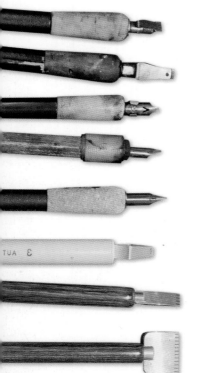

PENS

Broad-Edged Pens

The broad-edged pen may be the easiest of lettering tools for beginners. It's popular because of the natural thick-and-thin ribbon it makes, which has been adapted to the Western alphabet. Broad-edged pens come in the form of dip pens for calligraphy (Brause and Mitchell are good options), automatic pens for larger letters, and fountain pens. Broad-edged pens (sometimes called flat pens) can be used for many of the styles in this book; however, you may have to do a little manipulation with them to achieve some of the desired effects.

Ruling Pens

This is a forgiving tool and can be quite fun. A ruling pen has a knob on its side that you can turn to move the blades closer together, which produces a thin line, or farther apart to increase the flow of ink. They create forms that seem random and free—the opposite of traditional calligraphy. I usually vary the weight of line by changing from the side to the tip. It is a highly versatile tool, thus I recommend that you have several. You may choose to purchase new ruling pens, but you can also find a variety of shapes and sizes in antique stores, as they used to be part of drafting sets. Ironically, ruling pens were designed to draw very precise lines, but now they are a part of every calligrapher's tool kit as a tool that liberates and allows for experimentation. The downside is that you must learn to put the components together correctly or you could end up with a mess.

Pointed Pens

Pointed pens do not automatically produce thick and thin lines, but rather rely on pressure from the writer to produce variation in line weight. Pointed pens are made from different metals and have differing amounts of flexibility. Preferences vary, so you will have to try both. The White House employs calligraphers that use the pointed pen to create beautiful work for presidential affairs. It can also be used for informal work, but the downside is that it takes a lot of time to learn to control. Line weight variations depend on adding and releasing pressure, so the nibs have a tendency to catch on paper fibers and splatter. This pen requires patience.

INKS & PIGMENTS

Inks and pigments fall roughly into dye-based, pigment-based, and carbon-based categories. Carbon and pigment come mixed with water and binder. Some are waterproof, but they use a binder that is not generally good for your tools, so be careful. Carbon-based inks are permanent, as they don't fade over time. You can also grind your own ink with an ink stone and a Chinese or Japanese ink stick. I generally prefer the Japanese ink sticks. Higher quality produces better ink, and one ink stick can last for many years, so they are very economical. You can control the density and blackness with this method, and there are no harmful additives or shellac as there sometimes are in store-bought bottled inks. Dye-based inks should be used for practice because they are loose, which can lead to an interesting effect in writing. They will not clog your pen, but your work will fade over time.

Other pigments you will use are gouache, watercolor, and liquid acrylics. Gouache and watercolor are similar, although gouache is more opaque and dries to a velvet flat finish. Watercolors are transparent and are good when you want to see some variation in the color.

BRUSHES

Pointed Brush

The pointed brush may be the most versatile lettering tool available. It comes in a wide variety of shapes, sizes, and bristle lengths. I use Chinese, Japanese, and sable brushes. Like the ruling pen, the pointed brush is a wonderfully expressive tool open to wide variation. The characteristic "brushmark" is highly desirable. You can create work that has interesting texture and line with little practice, yet it can be challenging to exert control and produce consistent work. Many people turn to this brush to create illustrations or logos just for the mark-making element, even though they plan to digitally manipulate the strokes.

Broad-Edged Brush

The broad-edged brush is a versatile tool that shares the comfort of the broad pen but is good for surfaces that are not pen friendly, like fabric or thin Japanese paper. It's also a good tool for creating large letters, especially on a wall. The downside is that it has a fairly high learning curve and is not ideal for beginners. Broad-edged brushes have a ferrule (the part of the brush that holds the bristles onto the handle) that is either flat or round.

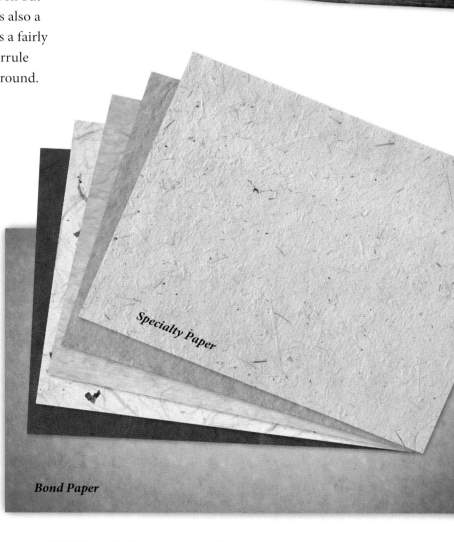

Bond Paper

PAPER

The subject of paper is vast, especially now that manufacturers are able to make lower-quality papers appear as if they are high quality. Some paper may look good, but it may bleed once you scratch the surface with your pen.

Paper can be broken down into three categories: practice paper, work paper, and paper that renders special effects. Lettering artists put careful consideration into the paper they use for their finished work.

Bond paper that is smooth and doesn't bleed is most useful for everyday use. For practice, you can use brown kraft paper or a cheaper bond paper (as long as it does not bleed). Higher-quality bond paper is worth the price. Canson® Marker Pad contains a smooth, white paper that is nice to work on and is somewhat translucent, allowing you to slip a sketch underneath for a guide.

Once you're ready to move beyond practice paper, you might want to try Arches® Text Wove and Arches Text Laid papers. They are durable with a slight "tooth," which may lend a nice quality to your letters.

BFK Rives is another good brand. Its papers are well suited for finished work, whereas bond and kraft papers are the best choices for practice. Every so often it is a good idea to work on nice paper, as it affects the quality of your work.

Specialty papers include handmade papers, colored papers, and rough watercolor paper, which can be used to achieve interesting, textured edges or contours in your lettering.

EXTRA MATERIALS

There are several other tools you will want to keep on hand: pencils; felt-tip pens; erasers; a straight-edge (T-square); tracing paper; white gouache for retouch, if necessary; cutting tools; markers; masking tape; mixing trays and palettes; and smaller, inexpensive brushes for mixing colors and loading pens.

Kraft Paper

Fundamental Elements

The first important technical elements for a beginner of hand lettering to learn are hold, stroke, and rhythm. You must learn to do these things correctly before you will be able to write consistent letters. It takes practice in order to work with confidence. A stroke should not feel hesitant, and the shape the tool itself is prone to create should be understood and applied to the letterform that you are rendering.

HOLD

In general, brushes and pens should be held fairly vertically, with the back end of the writing instrument pointing toward the ceiling. Avoid pointing the handle toward the wall behind you (exceptions to this rule involve some ruling pen techniques). Most beginners hold the brush or pen too flat. The hold is a gentle grip between the thumb, index, and middle finger (for support). You can achieve great results no matter what technique you use; however, you must compensate for an incorrect hold with the way you move the brush or pen, which artists often do. Great art has been produced regardless of the technique. I like a vertical hold because it is the best starting point from which to move in any direction or flip to any side of the pen or brush. If your hold is flat with a locked grip, it will be hard to be fluid later, and you may have to unlearn some bad habits.

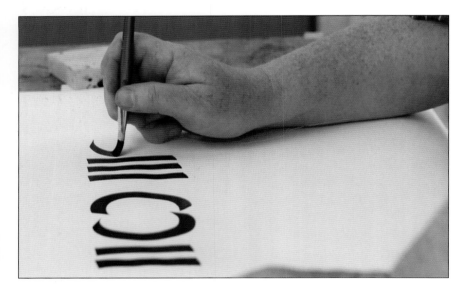

STROKE

Generally, stroke order should move from left to right, from top to bottom, and should attack vertical lines before horizontal lines. If you think a particular portion of a letter should be done in one stroke but it's just not working for you, try two strokes. Be careful and take your time.

The control of ink or pigment—getting the flow and the amount of ink correct—is a challenge for beginners. It's a combination of practice and knowing a few principles. It is a balance between having plenty of ink for flow and having a little bit for control (no blobbing, puddles, etc.). Because all inks are different, I usually have a palette or swatch of paper on which to test my pen or brush before I touch it to the page. With pen, I dip to load when the work is loose and free, and I load the pen using a brush when I must control the amount of ink on the nib to maintain consistency or to produce the hairlines on thin strokes. (See "Loading the Instruments," page 9.)

Dab a broad-edged brush on a palette after loading it with ink in order to shape its bristles and move the pigment to its tip. A pointed brush can be dipped and used for writing immediately, or dabbed on a palette first if the artist chooses to err on the side of caution.

RHYTHM

As you begin to create strokes and acquire a feel and confidence for making the most basic shapes (and doing so repeatedly), you will start to develop a rhythm. Rhythm is a natural process that helps unite the letters that are strung together. In lettering, our tasks start to become rhythmic, thereby gaining fluidity and momentum.

When we say we need to "warm up," we are referring to this natural phenomenon. Start with verticals; then move to horizontals, curves, and diagonals, and then try your hand at "key letters." (See "Key Letters," page 5.) Think about geometry and the quality of drawing. It might take some time to feel confident with the tools, but it will come together if you hang in there.

COMMON CHARACTERISTICS

Each tool has a unique technique associated with it, yet there are several aspects that overlap. Lettering, like calligraphy, has some characteristics common to most styles:

- Interesting line and characteristic shapes
- Proportions
- Variation in line
- Underlying structure
- Serif or sans serif (see box at right)
- Joints and connections
- Weight

SERIFS

Serifs are the details, or short lines, that stem at an angle from the ends of the strokes that form a letter. When an alphabet does not have serifs, it is known as "sans serif."

sans serif serif

KEY LETTERS

When you are learning a new style of alphabet, it's best to start with the "key letters." These letters will serve as your key to the straight and curved lines that are consistent throughout the other letters of the alphabet. For most alphabets, these letters are **i** and **o**. Next, practice **d**, **b**, **p**, and **q**, and then progress from there. When you group letters by shape, it's easier to create unity. This methodical practice will help you to learn the inner relationships that make the letters in the alphabet go together, instead of seeing the letters as 26 different shapes. Key majuscules, or uppercase letters, are **H**, **O**, **N**, and **E**. You can also organize letters into width groups. You will begin to see that the **m** and the **n**, as well as the **P** and the **R**, are made up of the same genes.

While learning a new alphabet, also take note of proportion. Classical letters have precise proportions, whereas unconventional letters usually do the opposite to create that "unskilled yet intentional" look.

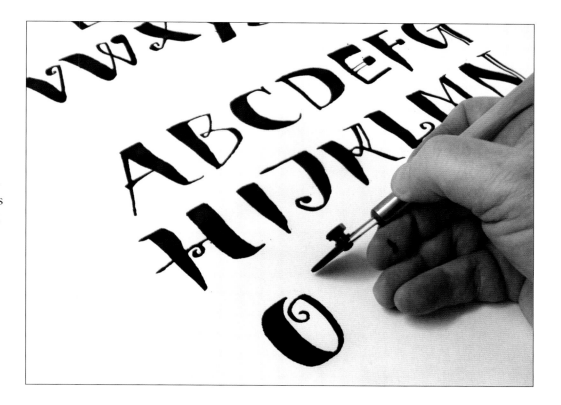

KEY LETTER GROUPS

i m o	b d p q g
a e c	k v w y z l
h n u r	f t s j

Basic Techniques

The scribe of the past would cut a reed or quill pen, thus shaping the nib to his or her preference. You may find that you need to modify tools to your preference as well. For example, metal pens sometimes have a polished and slippery feel. When this occurs, roughen the tip with some very fine sandpaper. As you master the techniques in this section, you will discover ways of modifying your tools that will make them work to your advantage.

Cornering When cornering, use only the corner of the pen's nib to create a thin line or to fill in detail. This technique is often used for hairlines and sometimes for ending serifs.

BROAD-EDGED TOOLS

With the broad-edged pen, start with simple, even strokes and hold a consistent pen angle. Most beginners start with a hold that is too tight and shallow, but should develop a hold that is more vertical. Even though many of the alphabets in this section are informal, you will find that it is helpful to use a T-square to draw straight lines on your lettering surface.

Broad-Edged Brush The broad-edged brush is somewhere between the broad pen and the pointed brush because you can borrow influences from both sides. Use it as a broad pen or use it as a "hybrid" brush.

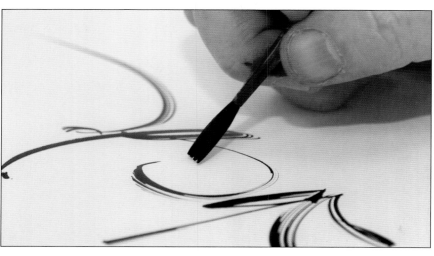

Broad-Edged Brush Hybrid This is an example of using a drybrush technique with a broad-edged brush to create an interesting effect. By doing this, the brush exhibits qualities of both a pointed brush and a broad-edged brush.

WAISTING

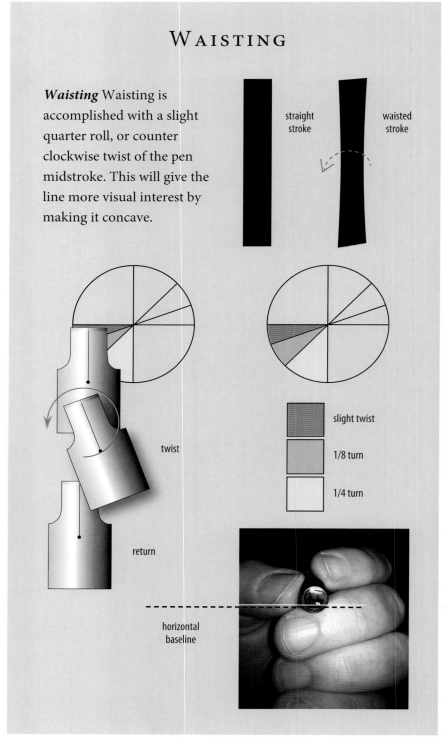

Waisting Waisting is accomplished with a slight quarter roll, or counter clockwise twist of the pen midstroke. This will give the line more visual interest by making it concave.

straight stroke

waisted stroke

twist

return

slight twist

1/8 turn

1/4 turn

horizontal baseline

RULING PEN

The ruling pen is a play tool for many. Sometimes it seems as if you are violating the paper, as marks are forceful and the paper fibers can get roughed up. There is no right or wrong way to write with this useful tool.

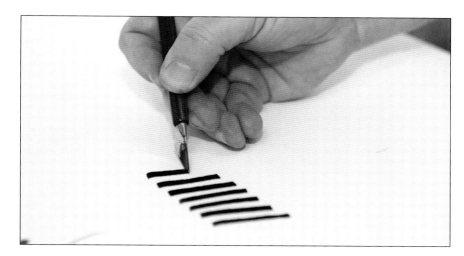

Folded Ruling Pen *The folded ruling pen creates a thin line when you work with just the tip, a thick line when you use its side, and every line variation in between as you move from one position to the other.*

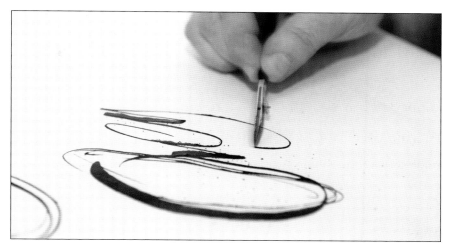

Experimenting with Marks *Here I am using what I call a flat hold, where I hold the pen as I would hold a knife at the dinner table. Although it is important to gain control of the ruling pen, the trick is to make the marks look slightly out of control.*

POINTED PENS

This type of pen is associated with "copperplate" and Spencerian script, but it can be used for contemporary handwriting as well, especially when the tip has been modified. Putting a slight broad edge on a pointed pen is a modification I commonly make by sanding it down with an Arkansas stone. Another way to change the effect of a pointed pen is by using the pressure and release method (at far right).

Flexible Pen *Traditionally, most calligraphy was done with either a pointed pen or broad-edged pen. Both create "shaded" lines, but they achieve the shading in different ways: A pointed pen employs pressure, and a broad-edged pen changes in direction. Above, I am adding pressure to a flexible pointed pen, which adds weight to the line.*

Pressure and Release *For this technique, add and release pressure applied to the point of your pen, which will spread and unspread the two blades. This motion controls the flow of ink onto the paper and allows you to create variations in line weight.*

> *"Have no fear of perfection—*
> *you'll never reach it."*
> *—Salvador Dali*

POINTED BRUSH

The pointed brush is full of variables and thus may be a little unnerving at first. I think it is the most valuable tool in many ways because you can draw, paint, and write in a variety of media and on almost any surface. Direction, pressure, and speed all affect the line you make with the pointed brush. The brush can be held upright or on its side; you can work with the point for thin lines or the broader base for thick lines. Develop a feel for this tool by practicing a variety of strokes.

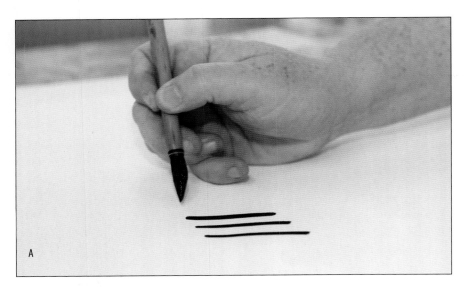

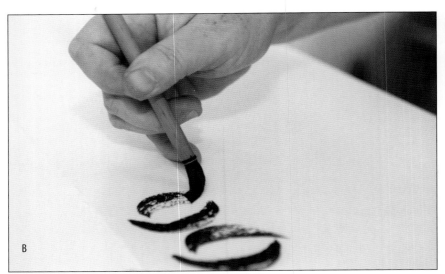

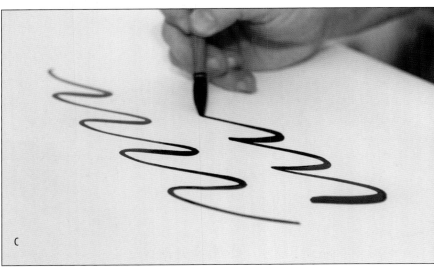

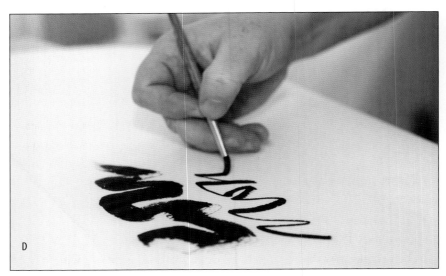

Pointed Brush Holds *These photographs show the common approaches to handling the pointed brush. You can either work on the tip of the brush (A), work on the side of the brush (B), or use a combination of the side and tip of the brush (C). You can also create variation with pressure (D). There are different types of brushes, and the shapes, sizes, and bristles all make a difference. Both the paper you use and the method you employ to load ink into the brush will also impact the final result.*

Chinese Brush

The Chinese brush offers more variation in its stroke than other pointed brushes. Some Chinese brushes exert control and others are more like mops, dragging along the paper and leaving a brushy mark that gives (or reveals) character. Just like the pointed brush holds shown above, there are several holds for the Chinese brush: holding the brush handle vertically, holding the brush handle at an angle, working with just the tip, and working with splayed bristles.

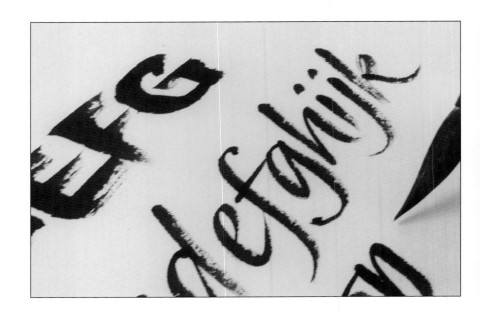

LOADING THE INSTRUMENTS

In fine writing, where precise control over the flow of ink is extremely important, use a paintbrush to load the pen with ink. To maximize consistency, I load the ink with a medium-sized brush. If I dip a pen, I almost always test it on a scrap of paper before committing to the final piece. In lettering, you must be able to predict what your tool will do—at least to some degree. Once you have established control, you can take more chances. Otherwise, it is simply a matter of personal preference.

Beginners have trouble judging ink dilution. If you are dipping and you load too much ink into the pen (in an attempt to extend the duration of your writing time without having to reload), you will end up with blobs. If you do not load enough ink, you will be reloading too frequently, which creates a break in rhythm. Practice is the key to fine tuning your loading skills.

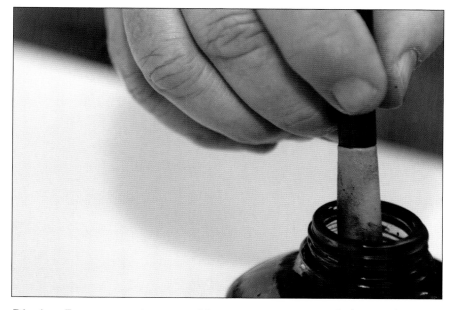

Dipping For more spontaneous writing, you can get away with dipping the pen in the ink. Just be aware that the first stroke you make on the paper will release the most ink; subsequent strokes will release less and less ink.

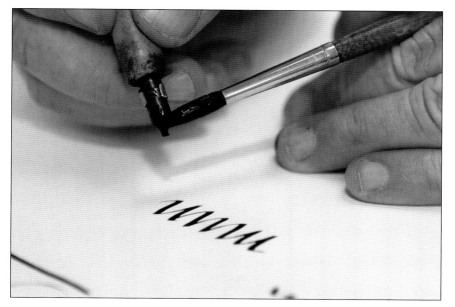

Using a Brush Begin by taking the loaded brush in your left hand (if you are right-handed). If writing at a small size, carefully touch the tip of the pen with the brush and load a little ink into the reservoir. How much ink you load depends on how small the writing, how fine and absorbent the paper, and how fluid the pigment (ink).

LOADING COLORED INK & PAINT

When working with color, you will dilute your ink or paint with water to varying degrees depending on the effect you want to achieve. Very controlled (fine) writing can not be expected with loose, watery ink. I often grind my own sumi ink for control. Higgins Eternal Ink has a controllable consistency, but you may want to dilute it if you are writing quickly. I find that an eyedropper is a handy tool for loading my pen when I want to create multicolored marks. (See "Making Multicolored Marks," below.) The variables to consider any time you are diluting ink or paint and loading your writing instrument are the type of pen (or brush) you are using in relation to the size of the lettering, the density of the ink pigment, and the thickness and absorbency of the paper.

MAKING MULTICOLORED MARKS

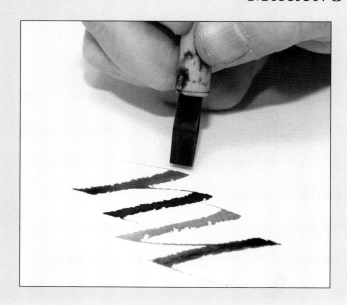

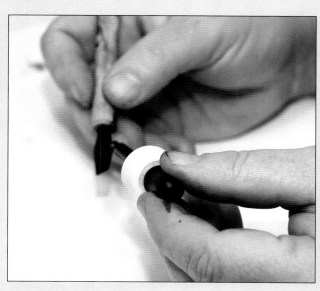

You will need two jars of water: one with clean water for loading your pen and mixing paints; one for rinsing your pens. Start by dipping your pen in the clean water. Then use an eyedropper bottle to add a bit of diluted watercolor to one side of the pen (such as blue); add another color to the other side of the pen (such as green). Then test your stroke.

Classic with a Twist

Classical lettering is refined and beautiful, and its letters have withstood the test of time. One of the most celebrated examples of this style can be found at the base of the triumphal Trajan Column in Rome. The Trajan Inscription contains the most elegant forms of Roman lettering, and it was written nearly 2,000 years ago. Imagine that. We still use the letters of the Roman Empire! This is because you cannot improve them—you can only alter them. They are considered to be the highest in the letterform pyramid. I recommend that any serious lettering artist do a thorough study of them. They are a fine balance of form and function. They are (unfortunately) also difficult to replicate well. In this section, I have included some personal variations that are not as difficult to create as the Trajan letters, but exhibit some of the same elegance. They are done with a broad-edged brush or pen. Variations can be found in history from 2,000 years ago until present. These letters were studied in the Middle Ages and during the Renaissance era, and they are still studied today.

There are several ways to approach Trajan variations: written, drawn, or built up with broad or pointed tools. In writing them, you will learn a few special techniques that will be useful for other hands as well. My purpose is to share methods that are not too demanding with the assumption that you may not want to be purist, but rather that you will want to create beautiful letters that are placed well on a page.

TOOL BOX
Broad-Edged brush
Broad-Edged pen
Modified pointed pen
Ruling pen

ZENFUL

The Roman Empire's monumental caps are still the standard of excellence today, and they require a great deal of effort to learn and replicate. This adaptation is an elegant and less difficult version of the Roman Imperial Capitals. Zenful is a narrow Roman alphabet without serifs, with highly modular shapes in its curves, and a soft triangular motif. I have been developing this alphabet into a typeface (font) for the last four years. This alphabet has strong links to classic function and form. I created these letters using a broad brush with a round ferrule.

ABCDEFG
HIJKLMN
OPQRSTU
VWXYZ &

LUX ET UMBRA VICISSIM
SED SEMPER AMOR

"Light and shadow by turns, but always love."

LATINA

Latina letters are playful as they bounce on the baseline, yet they contain the elegant lines of Roman capitals—delicate and airy. I created these letters with a broad-edged pen using a few techniques that will take some practice to perfect: twisting, cornering, and pressure and release. (See "Basic Techniques," page 6.) You have the choice to work with any of these techniques once you are familiar with the forms. For me, my choice of technique depends on the size of the letterforms and the look that I want to achieve.

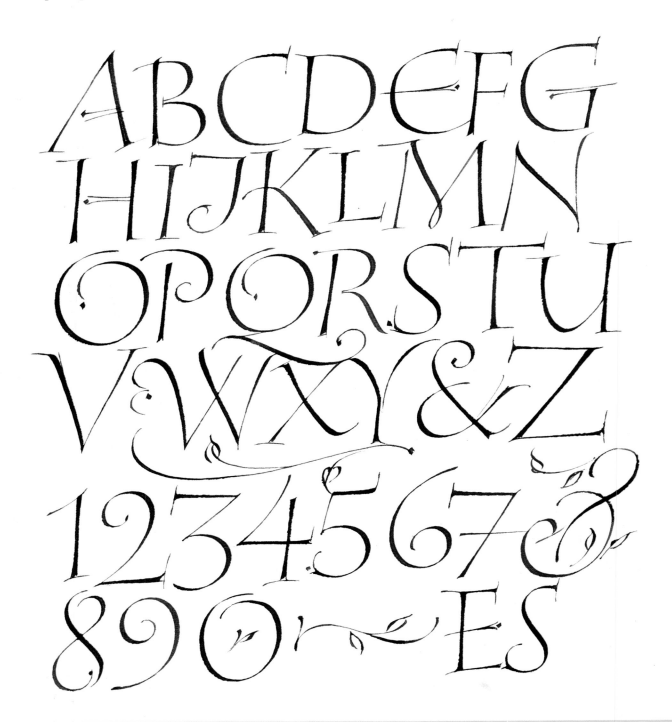

A LESS STRENUOUS METHOD

This Latin phrase was written with a pointed pen that I modified by shaping the point to a small, broad edge with an Arkansas stone. This helped the pen to function as both a pointed pen (flexible width) and broad pen. I created these lines by simultaneously building up the letters and using pressure and release.

PARVIS · IMBUTUS ·
TENTABIS · GRANDIA · TUTUS

"When you are steeped in little things, you shall safely attempt great things."

Libretto

Libretto is a flowing script with strong calligraphic leanings, which serves as a basis for my other ruling pen alphabets and for gaining control of the ruling pen. Start by practicing the straight and curved lines that form this alphabet. Then move on to O, G, C, and Q. Once you've mastered those letters, move to B, R, and P, and then move on to the rest of the alphabet. In other words, you should warm up with families of letters rather than start with A and work your way to Z. You want to feel the strokes by repeating them. Once you're warmed up, you can move to words and continue to work on individual letters that are giving you trouble.

ABCDEF
GHIJKLM
NOPQRST
UVWXYZ

abcdefghijk
lmnopqrstuv
wxyz Piano

Brushstroke

If an artist wants to make letters by hand, oftentimes they would like the lettering to have that "hand done" touch. With the brushstroke method, the letters display the characteristics and changes in transparency of the animated stroke.

The brush continues to be popular—partly because of its versatility and partly because it is a liberating and expressive tool. A brushstroke can communicate everything from power to delicacy and has a very long heritage—especially in the East. The Chinese and Japanese (along with other Asian cultures) have developed writing to a very high level, and the brushwork in the best of Asian art is deserving of study and admiration. Abstract expressionist painters were heavily influenced by the powerful brushstrokes of the East, where the way each stroke is executed is a high art. In the West, the brush is an experimental tool for creativity.

Even when not being wielded in a traditional manner, the brush is still a great mark-making tool. Simply by viewing its mark, one can see where the stroke started, its speed and direction, and where it ended.

The most challenging aspect of learning the brushstroke is becoming accustomed to what the stroke wants to do and absorbing this into your subconscious, which will allow you to create with its natural shape. When you pick up the brush, you will discover it is not the easiest tool to control—you must become familiar with its "inner rules." (See "Pointed Brush," page 8.)

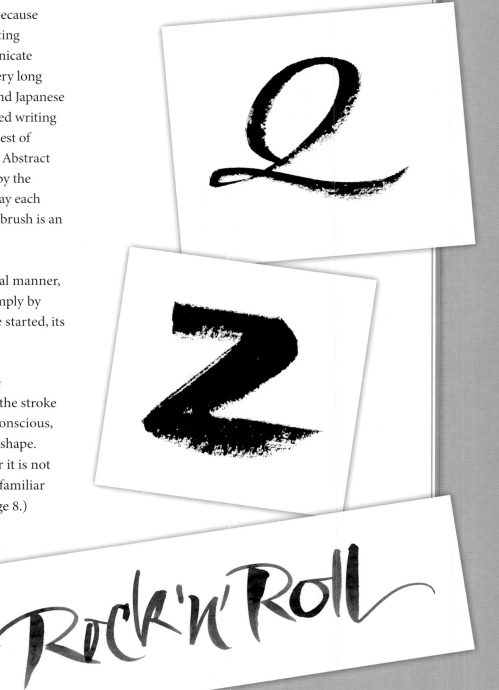

Anime

Written with ink and water to achieve a variety of tones, Anime is basically narrow and medium weight, with the occasional wider letter and heavier weight stroke. If you are consistent with the basic rhythm, these two variations will go a long way to giving the feeling of variety and—depending on the quality of your strokes—a degree of individuality. Pressure and release in rapid movement is necessary to create variations in each stroke.

abcdefghij

klmnopqrs

tuvwxyz

ABCDEFGH

IJKLMNOPQ

RSTUVWXYZ

Euro Rock'n'Roll

BEIJING

For this alphabet I used a large Chinese brush. Allow the bristles to make their characteristic marks by finding the right balance of ink loaded in the brush according to the paper's receptivity. Some papers absorb a lot of ink (Japanese papers are sensitive in this way and will help capture every nuance of stroke), but it is possible to get interesting effects on rough watercolor paper or Arches Text Wove as well. You should experiment on all types of paper.

The basic strokes are as follows: press, move, stop, then lift to make a bonelike stroke. You can press and move while lifting slightly to produce a stroke that tapers off. It will take some practice to feel free in your movements, but this type of brush makes very characteristic marks, so it should be fun. In this alphabet, the side of the brush is used more than the tip, occasionally "squashing" the hair when the ink is running out to create rough drybrush marks.

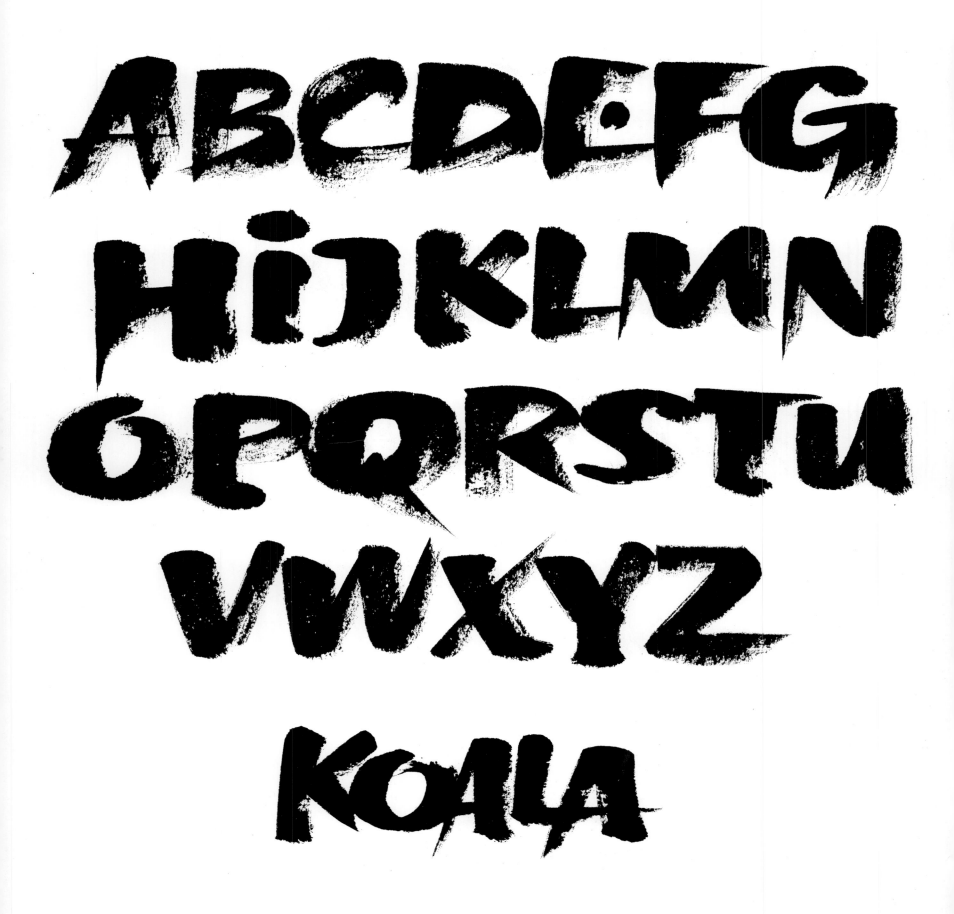

FRESH

This energetic alphabet, which I formed on Japanese paper, is all about finding a good match between ink and paper. Any pointed brush should work for you, but remember that every brush produces a different result. I like to collect brushes and learn the characteristic mark of each; then I choose based on my experiences. Write these letters quickly, keeping in mind that rhythm and energy are the important factors in this style. The strokes are a mix of the side and point of the brush, so practice several holds and stroke variations to learn what works for you.

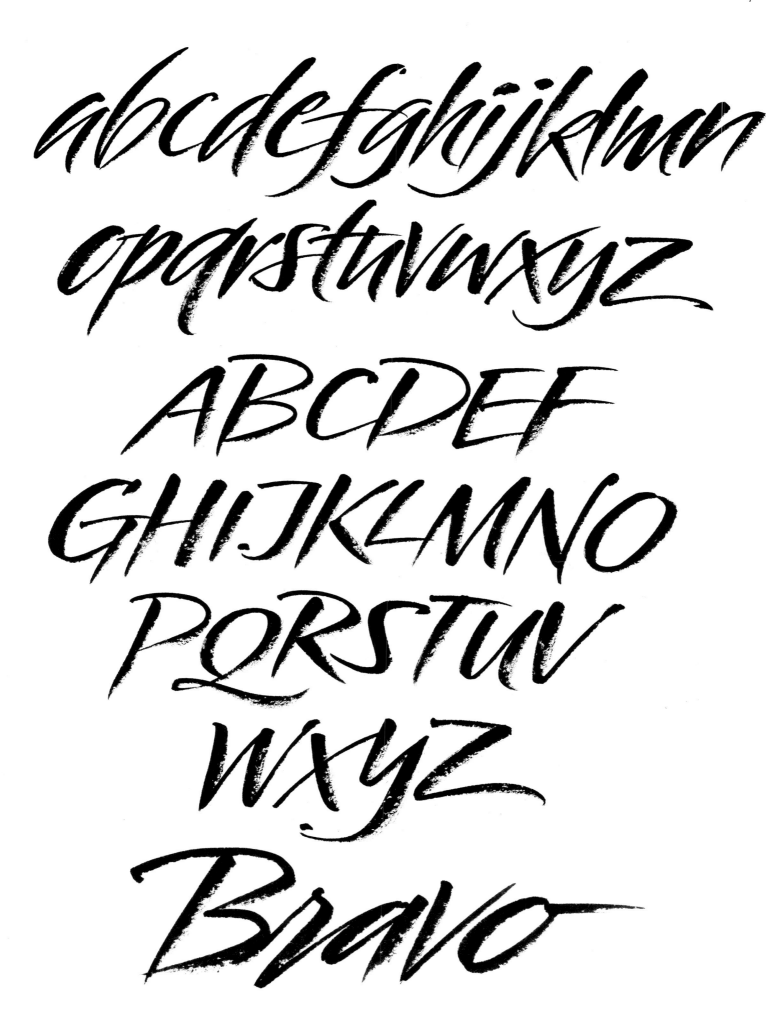

Fun & Funky

This lettering is unabashedly expressive. It begs for attention. It is less disciplined than classic-inspired hands, and presently it's a bit trendy. You can use these styles in place of typography, where it complements the perfection of the computer with a human element. There is a culture to this type of work, and it is mostly associated with youth and creativity. (Picture your high school notebook.) You can draw or write these letters with any tool. I prefer the ruling pen, but you can use any instrument with which you are comfortable. Once you get the hang of the basic rhythm, you can invent your own alphabet. You do not need every letter to be crazy or different. In order for the variety to work, you must establish some order or unity to the letters. That might sound funny, but you get more "pop" on your creative play if you restrain in areas to provide the stage, or backdrop, for the drama.

TOOL BOX
Broad-Edged pen
Pointed pen
Modified pointed pen
Ruling pen
Folded ruling pen

FUNK 49

I created Funk 49 with a folded ruling pen. The characteristic stroke has a taper, and the weight feels a little random. Despite this, notice that it still has a nice movement and rhythm. Using the side and tip of a ruling pen are the two basic moves you will employ. The advantage of the ruling pen is that it does not create fixed-width lines, thereby allowing you to create interesting shapes. Unfortunately, this "advantage" is also the downside, as you need to learn to control the pen before finding consistency.

ABCDEFG
HIJKLMN
OPQRSTU
VWXYZ&·

abcdeffg
hijklmno
pqrstuv
vwxyyez
Super

SATURNIA

I created Saturnia with a ruling pen, but you could easily create these letters using the cornering technique with an automatic broad-edged pen. This is a mix-and-match alphabet hung on a structure of square-shaped, narrow letterforms, with the occasional wide letter. As in drawing, fantasy can be introduced at any time.

abcdefghijk

lmnopqrstu

vwxyz aes 123

4567890 ABCD

EFGHiJKLMNO

PQRSTUVWXYZ

& Taxi

POLYLINE PILE-UP

Polyline Pile-Up, which pairs a doodlelike quality with sophisticated play, is a good match for the ruling pen. Characterized by lots of movement and personality, these letters can also be created with a pointed pen or pencil. As in any other alphabet, one must grasp the idea of dynamic balance (the amount of black versus white that each letter contains) with a touch of uncomfortable variation. The lines dance around the narrow, squarelike structure that makes up each majuscule. This alphabet serves as a good way to both practice and play at the same time.

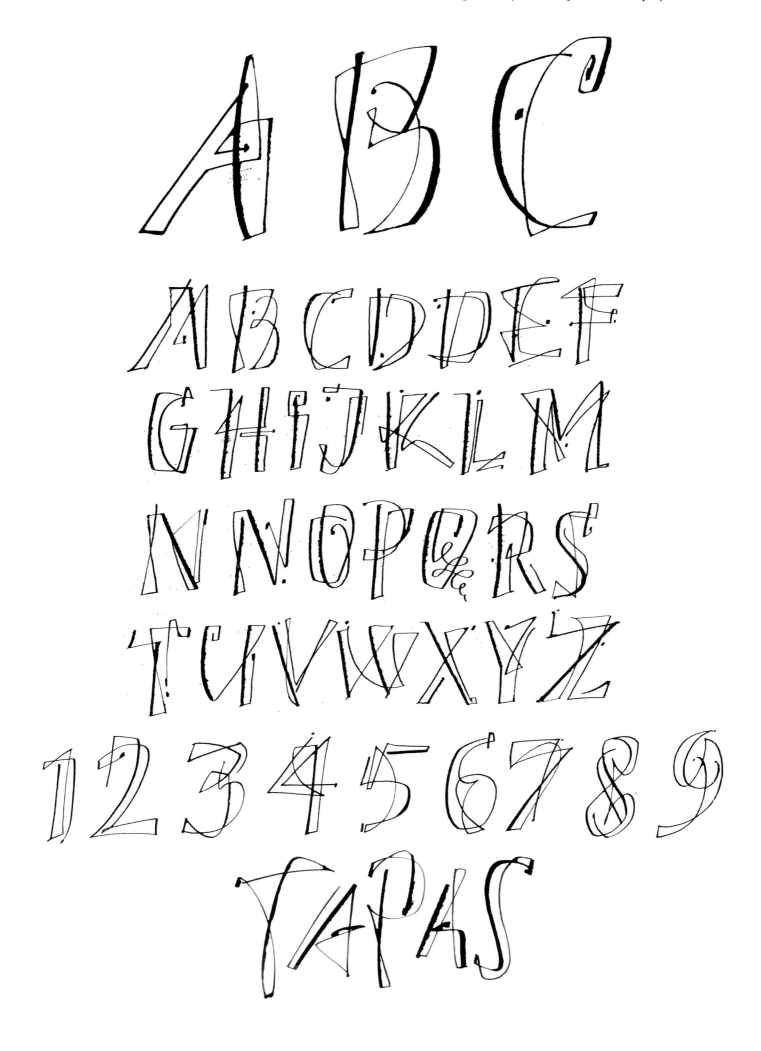

Edgy

Edgy styles are sophisticated

yet a bit aggressive, or "forward." This lettering has beauty but does not fall into the "pretty" category that is normally associated with calligraphy. This group has calligraphic underpinnings but seeks to put more action and expression on the page. Many of these alphabets can be created with any writing instrument— each tool produces different variations. Notice the weight placement: Broad tools will place the weight at a low-to-high axis, whereas the ruling pen and pointed brush will do the opposite. I prefer to combine the two influences to create "hybrid" type effects; however, I don't recommend this for beginners (unless you have great visual judgment). It takes a while to learn the rules before you can know which ones to break. When you want to create lettering with a contemporary feel, this style is a good bet.

TOOL BOX
Broad-Edged Brush
Pointed Brush
Broad-Edged pen
Modified pointed pen
Ruling pen

Manic

You can replicate this alphabet using a pointed pen or a ruling pen. Focus on creating a balance between strokes that repeat and those that introduce variation. Also be mindful of the dynamic balance (amount of black versus white that each letter contains). The letters feel a bit unpredictable, yet they harmonize. Try using a flexible pointed pen with a broad edge to create an exciting stroke that will produce a bit of splatter. Broken pens work as well. Also, your first efforts are likely to be too busy—so think to yourself, "Less is more."

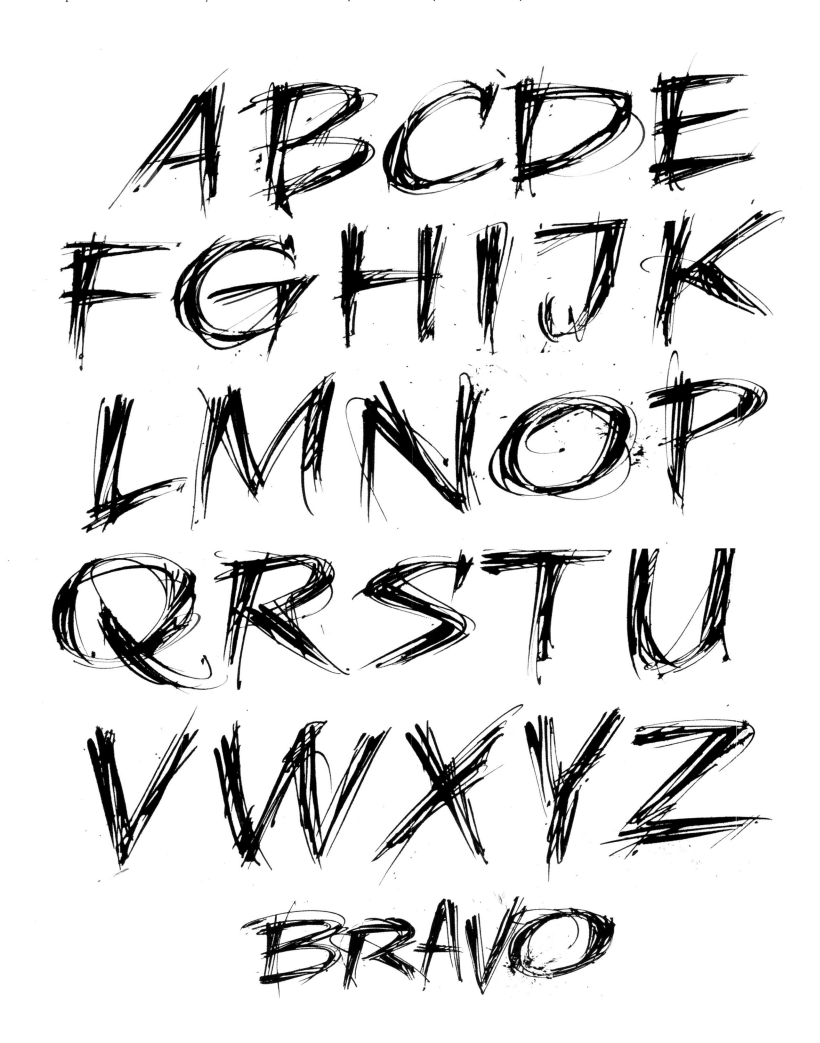

BOUNDARY

Boundary is a pen-written script in a contemporary, upright italic form. It is a cross between italic and an upright cursive, with more movement and a less predictable weighting pattern than straight italic. It is best to begin writing this alphabet with an automatic pen.

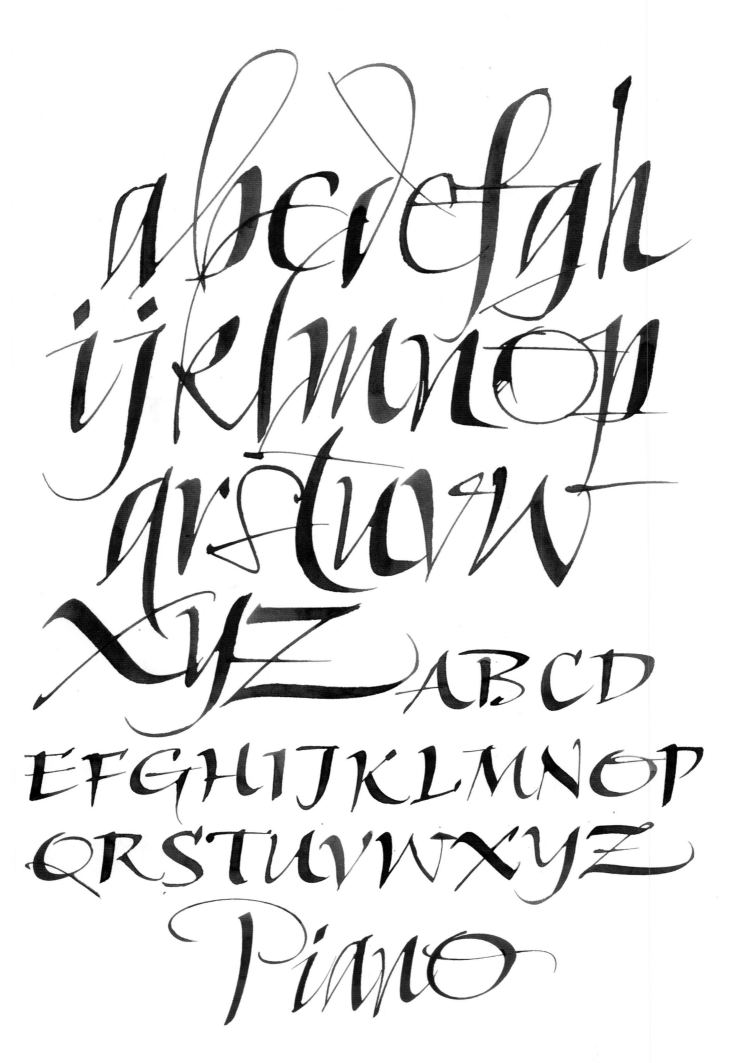

INTERTWINE

Intertwine is an alphabet of capitals with a fairly light weight (you can adapt them to be heavier or lighter), which I completed with a ruling pen. The appeal of these letters is that you can stack or arrange them in a "lock-up"—a composition that features an interesting form and pattern. In all lettering, the form, rhythm, and movement interact, and the aim is to create an overall pleasing pattern with cascades of movement.

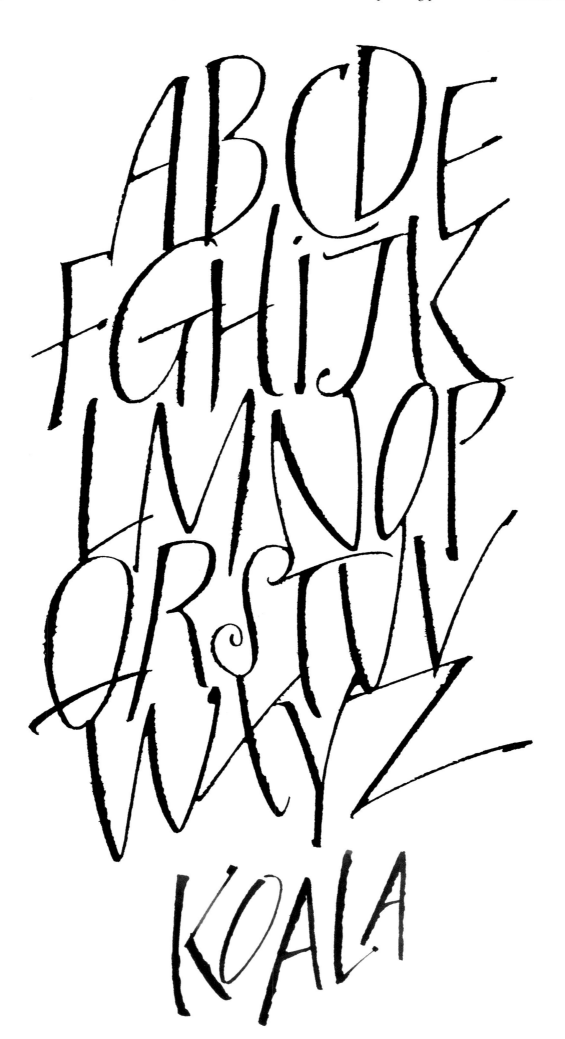

Quirky & Curlicue

Lighthearted and related to the Fun & Funky style (see "Fun & Funky," page 18), this category is "innocent" and happy, and it may exude a bit of humor and character. These alphabets are preoccupied with self-expression. They say, "Look at me!" Borrowing on this style's narcissistic flair, try to make these lettering styles "all about me."

When drawing the alphabets in this section, think of both your audience and of what "voice" you imagine is behind the letters. Once you determine this, you can add or take away details to suit your tastes, and you will know that your work is communicating the tone that you intended. It's possible that you will create letters that stand alone as purely decorative works of art.

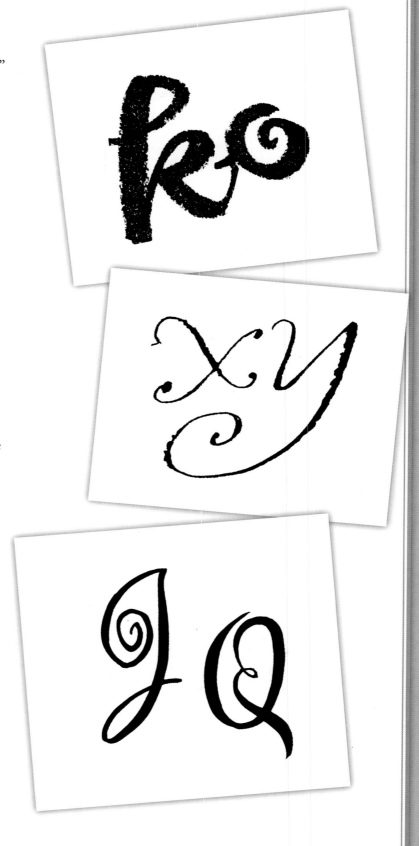

Tool Box
Pointed brush
Pointed pen
Ruling pen

BOING! REGULAR

This alphabet can go in several different directions, depending on attitude. It can be viney and *au natural*, it can be busy and quirky, or the lines can be smooth or broken. I created this version with a pointed brush, adding pressure to produce the slight variations in line weight. The letterforms are on the narrow side to allow for the curlicues that encroach on their neighboring letters.

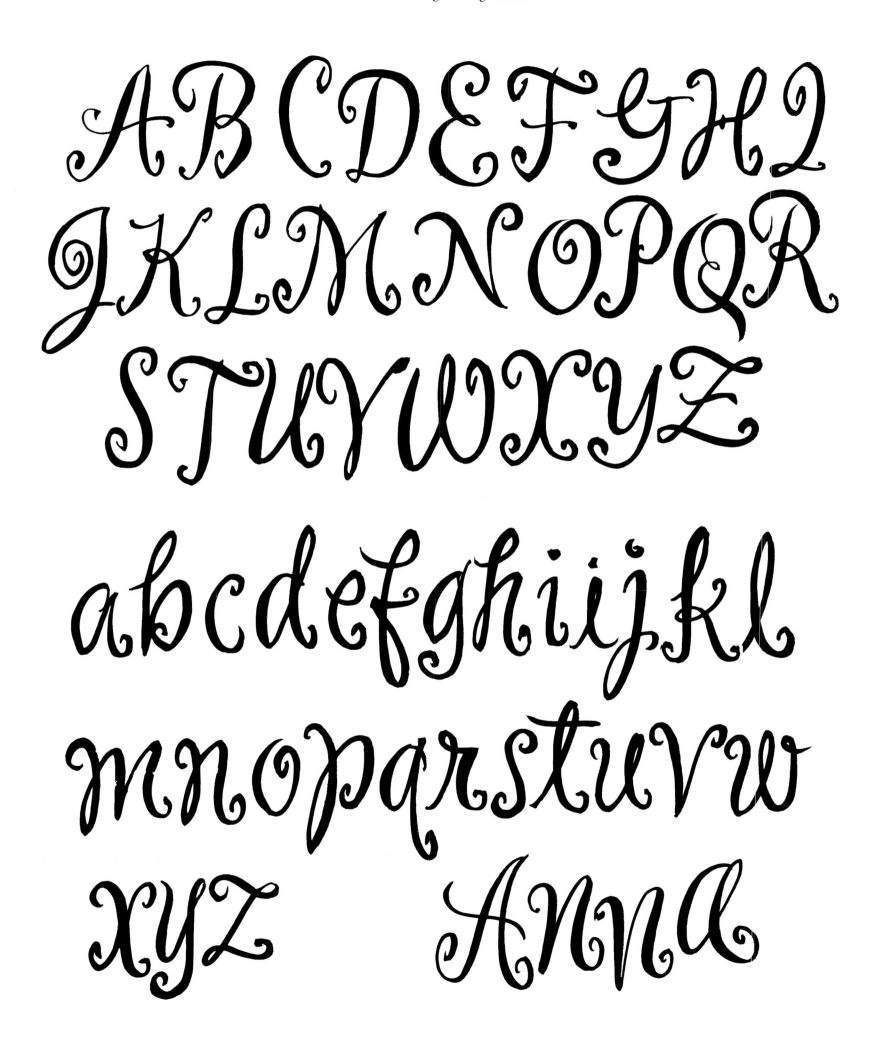

BOING! HEAVY

This version of the Boing! alphabet still displays details such as the curlicue and the slightly broken curves, but it is bold and should be written with a pointed brush and a bit of self-involvement. You can create these busy letters in a painterly style, which will emit a look that is both fun and decorative. Your brush technique may vary depending on what paper you use, but you will employ the side and tip. Rough and absorbent papers will render attractive and slightly unpredictable results. Learn to differentiate between the character, the basic structure, and the details that can be changed to suit your taste. Some aspects must be copied, but others can be manipulated.

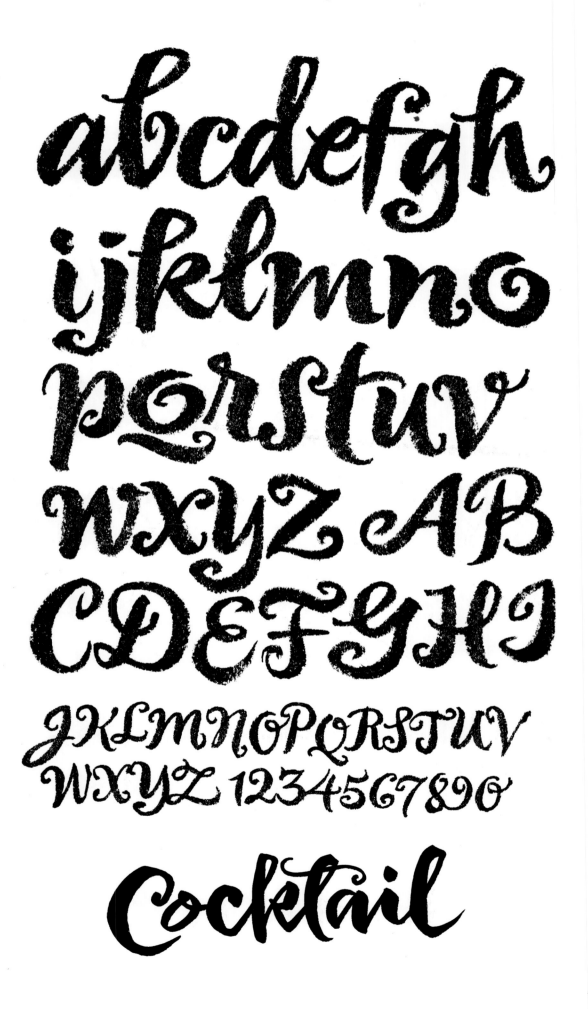

Ting!

I created this alphabet using a ruling pen, but it can also be rendered with a pointed pen. The main features of the letters in the Ting! alphabet include curlicues, lots of bounce, and the strategic placement of dots at the end of strokes.

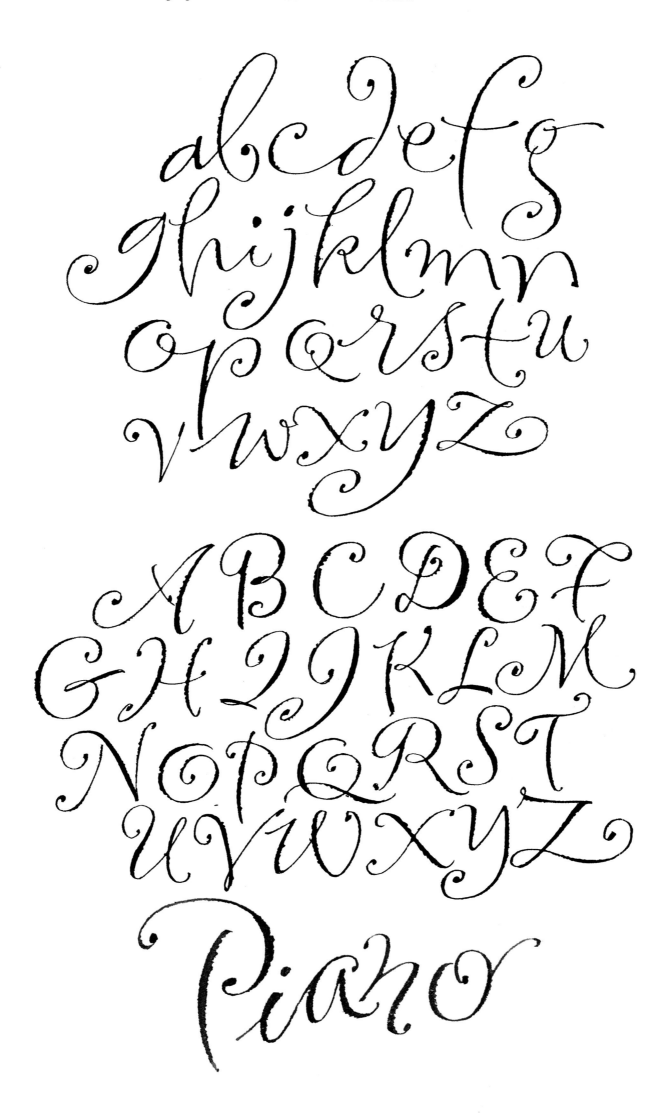

Chromatic

Once you are comfortable

with your writing instruments and basic techniques—and after you have mastered the letters you intend to embellish—you will be ready to attempt color. I drew the two alphabets in this section with a ruling pen and a broad-edged pen loaded with high-quality watercolor paints. When choosing the colors you are going to implement in your lettering art, keep in mind the basics of color theory as well as the tone of the message you are trying to convey.

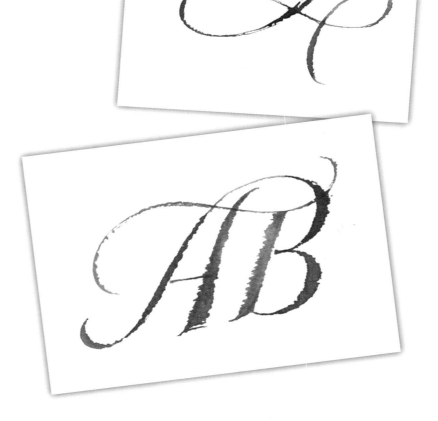

TOOL BOX
Folded ruling pen
Broad-Edged pen
Eyedropper bottle

CHEER

I wrote Cheer with a folded ruling pen on rough watercolor paper. This alphabet bears a resemblance to 19th-century scripts but involves taller minuscules. You can experiment with the height ratio of the majuscules and minuscules, but avoid making the minuscules exactly half the size of the majuscules (which I call "avoiding 50–50"). If you have the room, you can elaborate with ascenders, descenders, and the last strokes of a word or group of words. Symmetrical balance is old-fashioned, but dynamic balance is full of tension and resolve, resulting in more interest.

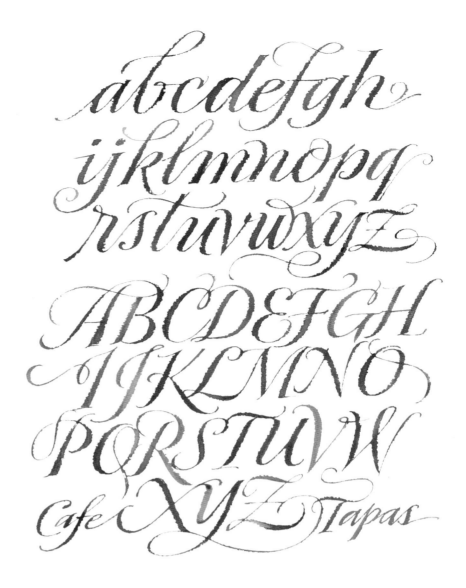

KALEIDOSCOPE

Kaleidoscope is a mix of block letters and the occasional cursive letter. It appears to have more components because the block letters are different weights and sizes. Also, I make the letters very obviously hand-drawn, with no attempt at perfection. As you add color, keep in mind the amount of light and dark, which should balance out for the overall desired look. Otherwise, this alphabet can look too busy. Think 70–30, meaning 70 percent bold and 30 percent light—never 50–50.

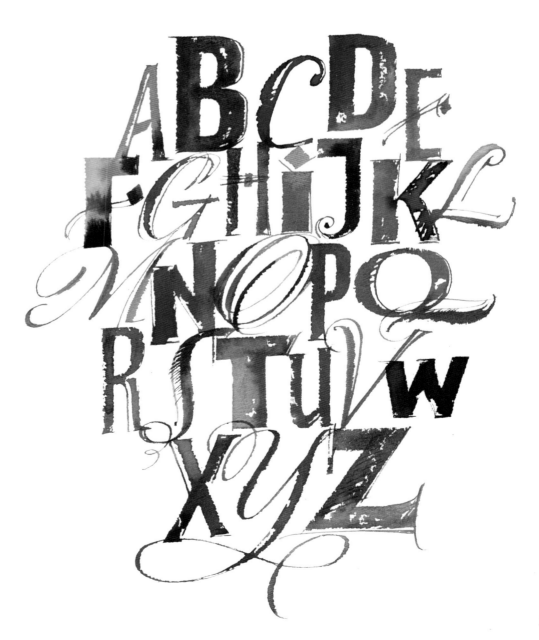

Gallery

Lettering possibilities are infinite. Below are some additional alphabets created by renowned lettering artist John Stevens. After you become comfortable with your writing instruments, experiment to see what kinds of letters and alphabets you can create on your own.

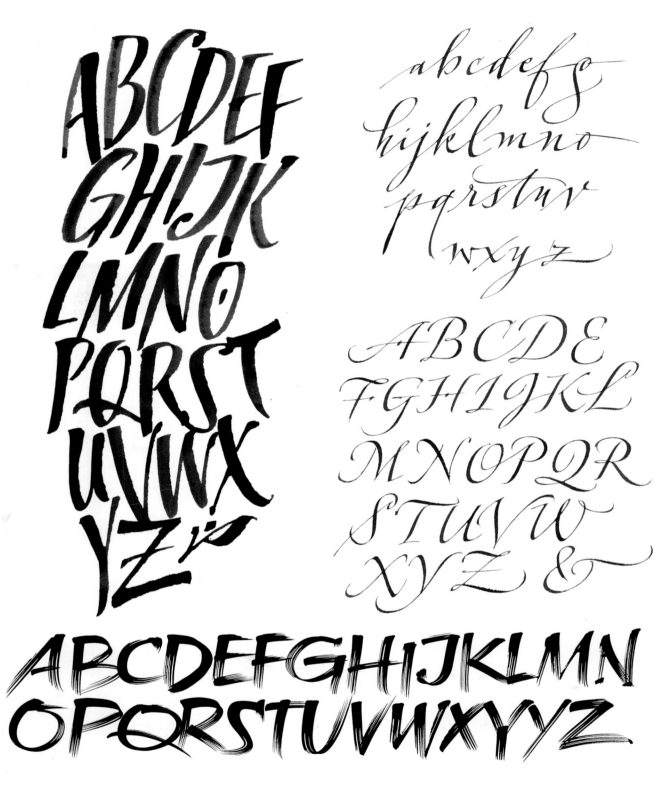

JOHN STEVENS John Stevens is an internationally known calligrapher, designer, and lettering artist with 30 years of experience. An art major and former musician, he found his true calling when he was introduced to lettering while apprenticing in a sign shop. Immediately hooked, he diligently studied letterforms, letterform design, typography, calligraphy, art, and design, scouring libraries to find everything he could get his hands on. John started a business as a freelance letterer and designer in the early 1980s creating lettering, calligraphy, and logo design for publishing companies and other businesses. John's prestigious client list includes *Rolling Stone, TIME, Readers Digest,* and *Newsweek* magazines; Pepsi; Atlantic Records; HBO; Lucasfilm; Universal Studios; Macy's; Bergdorf Goodman; IBM; Disney; and Bloomingdales, among others. Originally from New York, he now lives in Winston-Salem, North Carolina, where he has been a faculty member of The Sawtooth Center for Visual Art and is an exhibiting member of Associated Artists. He also teaches and is the faculty advisor and marketing director at Cheerio Calligraphy Retreats, a biannual retreat in the Blue Ridge Mountains. Visit www.johnstevensdesign.com.